CATS

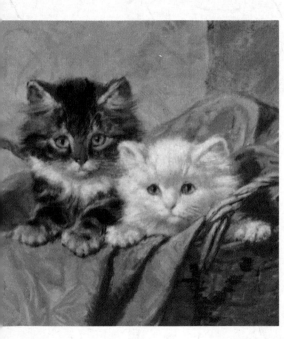

CATS

An Illustrated Treasury

Compiled by Michelle Lovric

COURAGE
BOOKS

an imprint of
RUNNING PRESS
Philadelphia, Pennsylvania

TO VARIOUS CULTURES THROUGH THE AGES, THE CAT HAS BEEN AN ENIGMA, A

FEARSOME BEAST, A FRIEND. ANCIENT EGYPTIANS WORSHIPPED THE CREATURE AS A

Introduction

GOD, WHILE IN THE MIDDLE AGES, THE CAT EARNED A REPUTATION AS THE WITCH'S

FAMILIAR. IN THE SIXTEENTH CENTURY, THE PHOBIA OF CATS BECAME MANIFEST IN

THEIR PERSECUTION AND SLAUGHTER.

FEAR OF THE CAT ORIGINATES IN ITS INSCRUTABILITY. ITS MYSTIQUE IS

IMPENETRABLE, AND ITS NATURE DEFIES EXPLANATION. WE VIEW THE CAT AS A

HUNTER, COMPANION, AND OUTRAGEOUS INDIVIDUAL. HOWEVER, THE CAT'S HIGHER

PURPOSE—OBVIOUS IN ITS BEARING—ESCAPES US.

HERE WE CELEBRATE AND ATTEMPT TO CAPTURE THE FELINE ESSENCE IN WORD

AND IMAGE. ALWAYS DECORATIVE, THE CAT SEEMS TO OFFER ITSELF AS AN EXPRESSION

OF HUMAN FEELING, WHILE STILL RETAINING ITS OWN DIGNITY AND STYLE. IN THESE

ILLUSTRATIONS, THE CAT VARIOUSLY REPRESENTS GRACIOUS MOTHERHOOD, RIOTOUS

YOUTH, AMOROUS MATURITY, A KEEN EYE, A WARM HEART, A SENSE OF HUMOR, AN

ALLURING ALOOFNESS, AND AN EQUALLY SEDUCTIVE COZINESS.

THE IMAGES IN THIS EDITION ARE PROVIDED BY A SYMPATHETIC SOURCE: THE

VAST ARCHIVES OF ROYLE PUBLICATIONS LIMITED, WHICH HAS BEEN SELECTING AND

COMMISSIONING FINE ARTWORK FOR GREETING CARDS FOR NEARLY 50 YEARS.

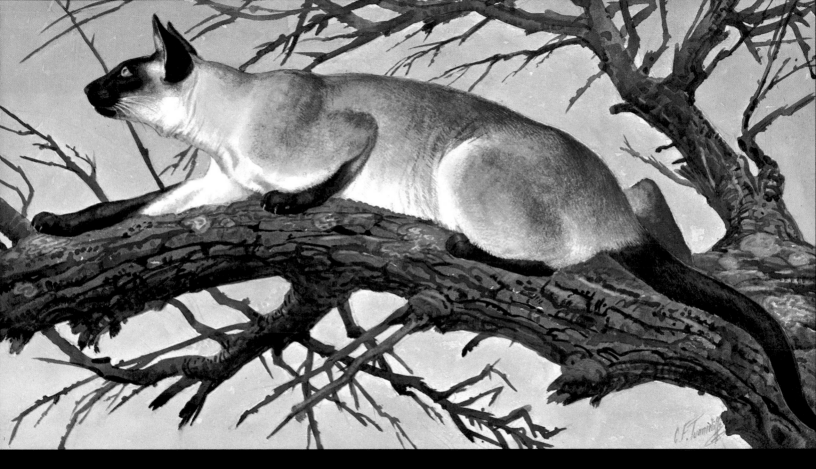

A cat is a lion in a jungle of small bushes

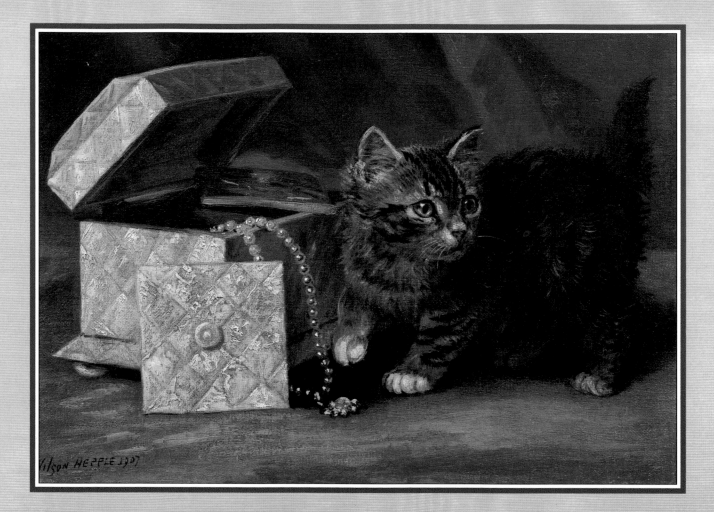

A

PHARAOH'S PROFILE, A KRISHNA'S GRACE,

TAIL LIKE A QUESTIONMARK.

Louis MacNeice
Irish Poet

The smallest feline is a masterpiece.

LEONARDO DA VINCI
ITALIAN PAINTER, WRITER, AND INVENTOR

*I*F A FISH IS THE MOVEMENT

OF WATER EMBODIED, GIVEN SHAPE, THEN A

CAT IS A DIAGRAM AND PATTERN OF SUBTLE AIR.

Doris Lessing
British writer

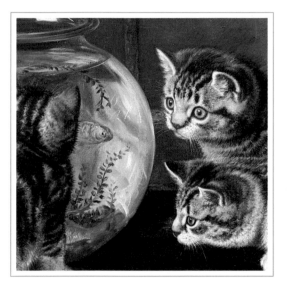

...the
wildest of
all the wild
animals
was the
Cat.
He walked
by himself,
and all
places were
alike to
him.

RUDYARD KIPLING
ENGLISH WRITER

OF ALL ANIMALS, [THE CAT] ALONE
ATTAINS TO THE CONTEMPLATIVE LIFE.

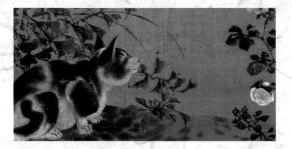

HE REGARDS THE WHEEL OF EXISTENCE

FROM WITHOUT, LIKE THE BUDDHA.

Andrew Lang
Scottish scholar and poet

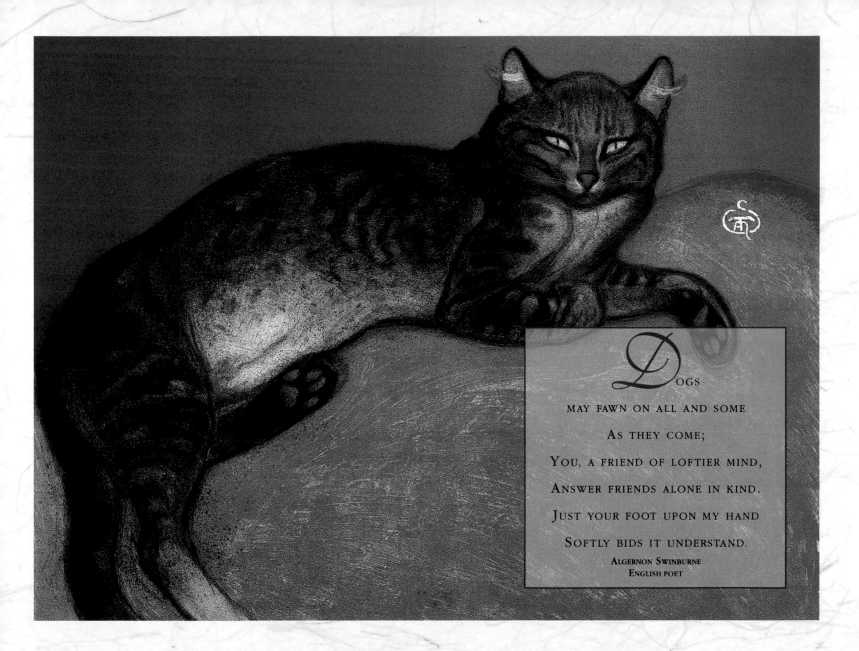

*D*OGS

MAY FAWN ON ALL AND SOME

AS THEY COME;

YOU, A FRIEND OF LOFTIER MIND,

ANSWER FRIENDS ALONE IN KIND.

JUST YOUR FOOT UPON MY HAND

SOFTLY BIDS IT UNDERSTAND.

ALGERNON SWINBURNE
ENGLISH POET

IF A DOG JUMPS INTO YOUR LAP IT IS BECAUSE HE IS FOND OF YOU; BUT IF A CAT DOES THE SAME THING IT IS BECAUSE YOUR LAP IS WARMER.

A. N. Whitehead
English philosopher

With dogs

and people

it's love

in big

splashy colors.

When you're

involved

with a cat

you're dealing

in pastels.

I like that

about cats.

LOUIS J. CAMUTI
AMERICAN WRITER

IT WILL CONSENT TO BE YOUR FRIEND

IF YOU ARE WORTHY OF THE HONOUR,

BUT IT WILL NOT BE YOUR SLAVE.

Théophile Gautier
French writer

fifteen

\mathcal{F}riendship between cats can exist, but more or less in the same way that it can exist for a not very sociable man...who when asked why he does not have any friends, replies, "I would like to have them...but they are so ignoble!"

PAUL LEYHAUSEN
FRENCH PSYCHOLOGIST

THE

CAT

KNOWS

WHOSE

LIPS

SHE

LICKS.

*Latin
proverb*

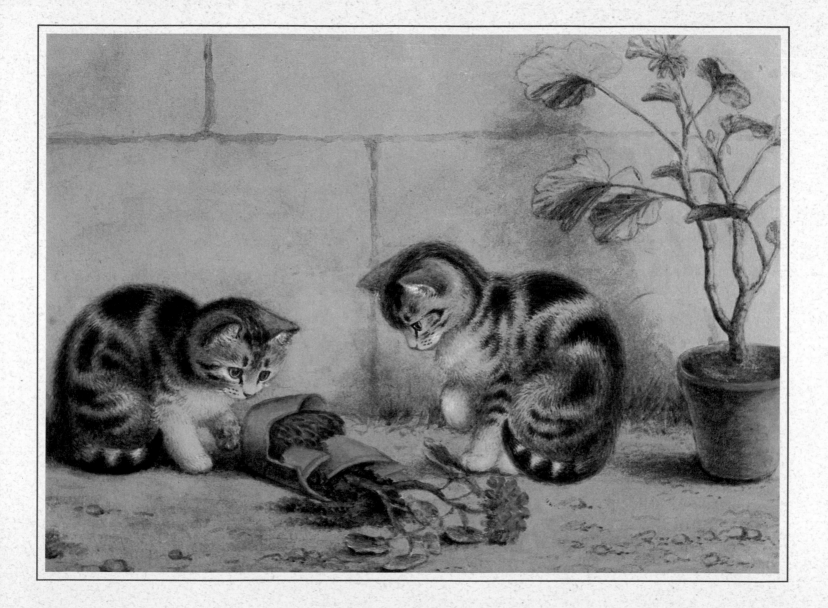

The real objection to the great majori-
ty of cats is their insufferable air of
superiority.

P. G. WODEHOUSE
ENGLISH HUMORIST

ONLY THOSE WHO DO NOT LIKE CATS KNOW ALL ABOUT THEM.

Jean Burden
American editor and poet

She understood now what cat lovers understood. You were with another being who didn't need your approval.

RICHARD BEN SAPIR
AMERICAN WRITER

I HAVE NOTICED THAT WHAT CATS MOST
APPRECIATE IN A HUMAN BEING IS NOT THE
ABILITY TO PRODUCE FOOD, WHICH THEY
TAKE FOR GRANTED—BUT HIS OR HER
ENTERTAINMENT VALUE.

Geoffrey Household
English writer

Cats refuse to take the blame for anything—including their own sins.

ELIZABETH PETERS
AMERICAN WRITER

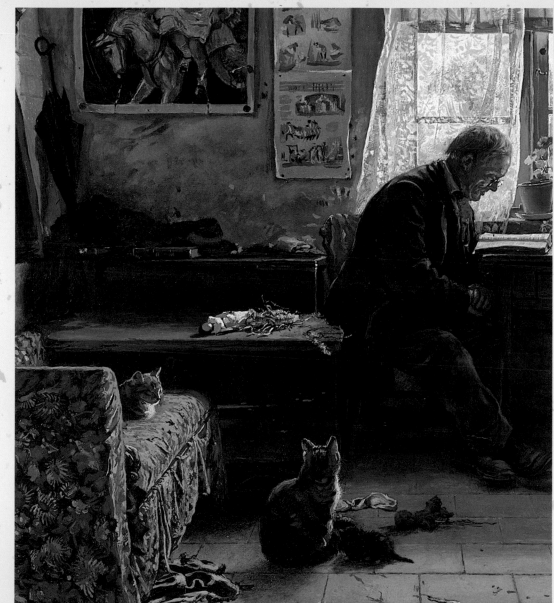

Cats hate a closed door . . . regardless of which side they're on.

LILIAN JACKSON BRAUN
AMERICAN WRITER

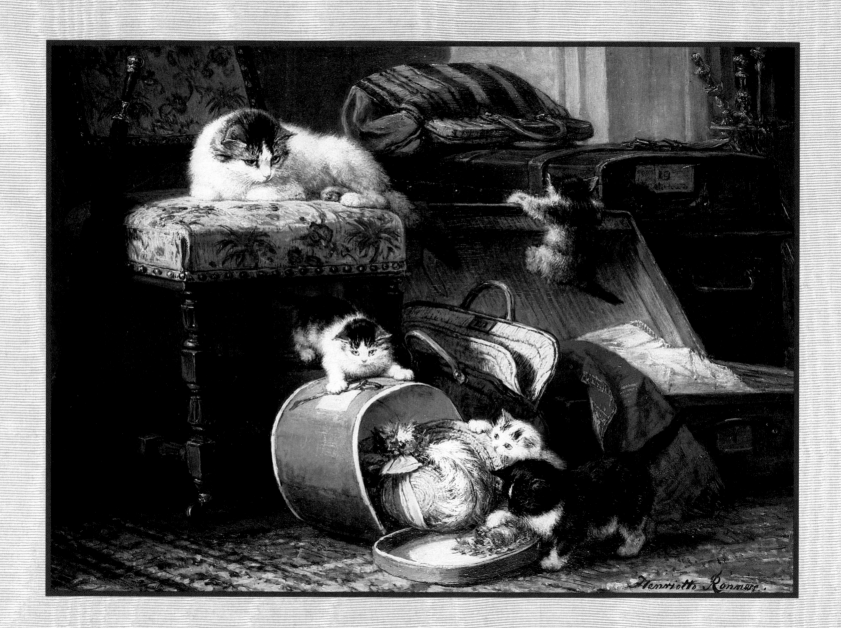

THE CAT WILL NEVER PART WITH ITS LIBERTY.... IT CONSENTS TO LIVE AS OUR GUEST; IT ACCEPTS THE HOME WE OFFER AND THE FOOD WE GIVE; IT EVEN GOES SO FAR AS TO SOLICIT OUR CARESSES, BUT CAPRICIOUSLY, AND WHEN IT SUITS ITS HUMOR TO RECEIVE THEM.

M. Fée
French naturalist and writer

I allow my cats

to express themselves,

never interfere

with their romances,

and raise them with dogs

to broaden their outlook.

MURRAY ROBINSON
AMERICAN WRITER

When my cats aren't happy, I'm not happy. Not because I care about their mood but because I know they're just sitting there thinking up ways to get even.

PENNY WARD MOSER
AMERICAN WRITER

WHEN I PLAY

WITH MY CAT,

WHO KNOWS IF

I AM NOT A PASTIME

TO HER MORE THAN

SHE IS TO ME?

Michel Eyquem de Montaigne
French writer

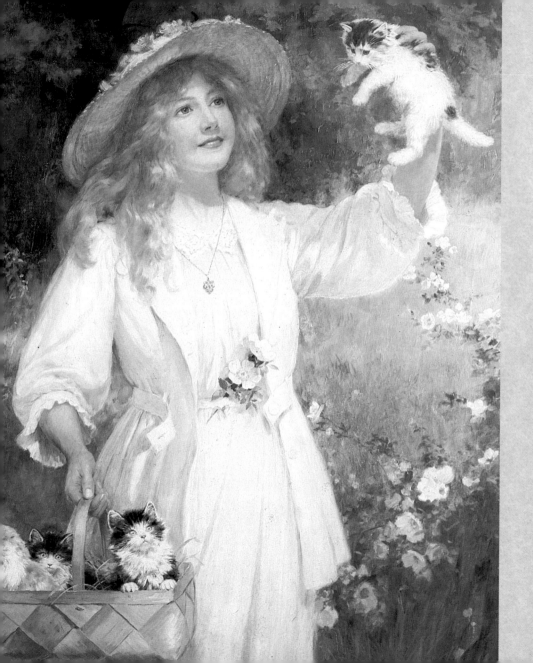

THOSE WHO'LL PLAY WITH CATS MUST EXPECT TO BE SCRATCHED.

Miguel de Cervantes
Spanish writer

c Cat

Cat the hunter, the devil, the sorcerer, the incarnation of evil, exists side by side with the creature of angelic grace, the protector of the hearth, the hero of countless adventures.

JEAN BURDEN
AMERICAN EDITOR AND WRITER

CRUEL, BUT COMPOSED AND BLAND,

DUMB, INSCRUTABLE AND GRAND,

SO TIBERIUS MIGHT HAVE SAT,

HAD TIBERIUS BEEN A CAT.

Matthew Arnold
English poet and critic

Once cats were all wild, but afterward they retired to houses.

EDWARD TOPSELL
ENGLISH WRITER

The cat is domestic only as far as suits its own ends; it will not be kennelled or harnessed nor suffer any dictation as to its goings-out or comings-in.

SAKI
ENGLISH WRITER

As to sagacity, I should say that

his judgment respecting the warmest

place and the softest cushion in a

room is infallible, his punctuality

at meal times is admirable, and

his pertinacity in jumping on

people's shoulders till they give him

some of the best of what is going,

indicates great firmness.

THOMAS HENRY HUXLEY
ENGLISH SCIENTIST

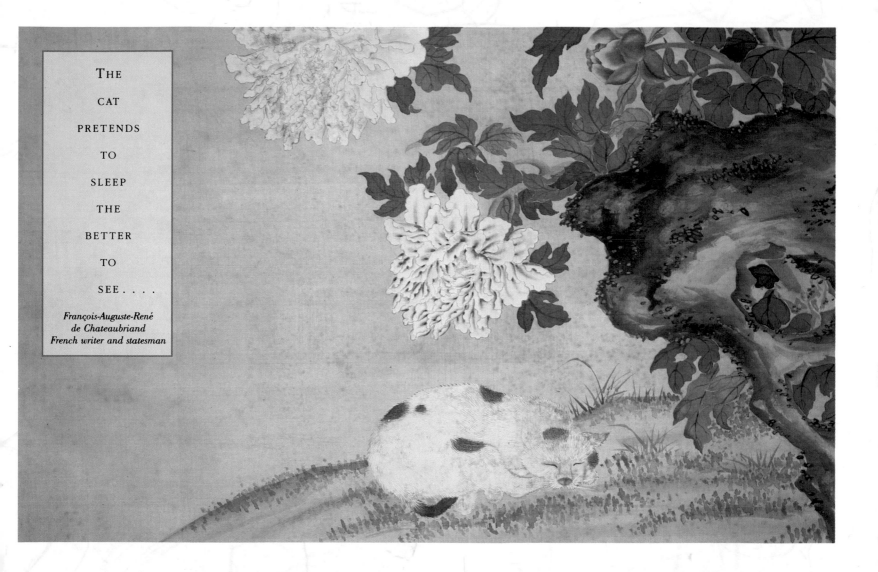

THE
CAT
PRETENDS
TO
SLEEP
THE
BETTER
TO
SEE. . . .

François-Auguste-René
de Chateaubriand
French writer and statesman

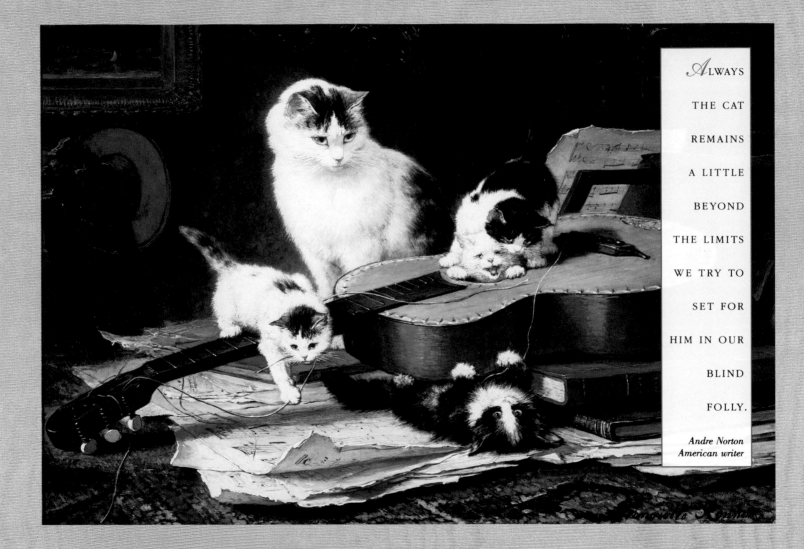

ALWAYS THE CAT REMAINS A LITTLE BEYOND THE LIMITS WE TRY TO SET FOR HIM IN OUR BLIND FOLLY.

Andre Norton
American writer

ONCE IT HAS GIVEN ITS LOVE, WHAT ABSOLUTE CONFIDENCE, WHAT FIDELITY OF AFFECTION! IT WILL MAKE ITSELF THE COMPANION OF YOUR HOURS OF WORK, OF LONELINESS, OR OF SADNESS. IT WILL LIE THE WHOLE EVENING ON YOUR KNEE, PURRING AND HAPPY IN YOUR SOCIETY, AND LEAVING THE COMPANY OF CREATURES OF ITS OWN SOCIETY TO BE WITH YOU.

Théophile Gautier
French writer

...when I returned home at night, he was pretty sure to be waiting for me near the gate, and would rise and saunter along the walk, as if his being there were purely accidental....

CHARLES DUDLEY WARNER
AMERICAN EDITOR AND WRITER

HOW MANY COLD AND LONELY MIDNIGHTS HAVE BEEN WARMED BY THE SIMPLE PRESENCE OF THIS SMALL BEING, WHOSE AFFECTION PERVADES OUR SOLITUDE?

Carl van Vechten
American writer and photographer

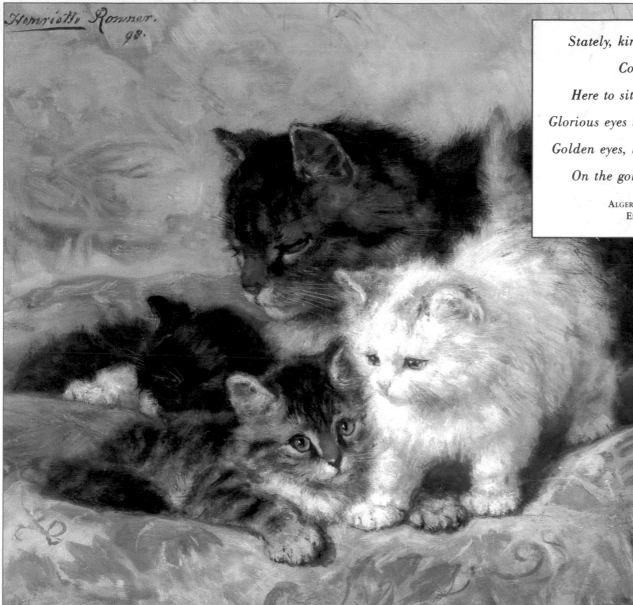

Stately, kindly, lordly friend
Condescend
Here to sit by me, and turn
Glorious eyes that smile and burn,
Golden eyes, love's lustrous meed,
On the golden page I read.

ALGERNON SWINBURNE
ENGLISH POET

She sits composedly sentinel, with paws tucked under her, a good part of her days at present, by some ridiculous little hole, the possible entry of a mouse.

HENRY DAVID THOREAU
AMERICAN WRITER

THE

CAT

WOULD

EAT

FISH

BUT

WOULD

NOT

WET

HER

FEET.

Proverb

. . . sits like any gossip at the casement, her agile tail reporting what she sees.

KATHERINE VAN DER VEER
AMERICAN POET

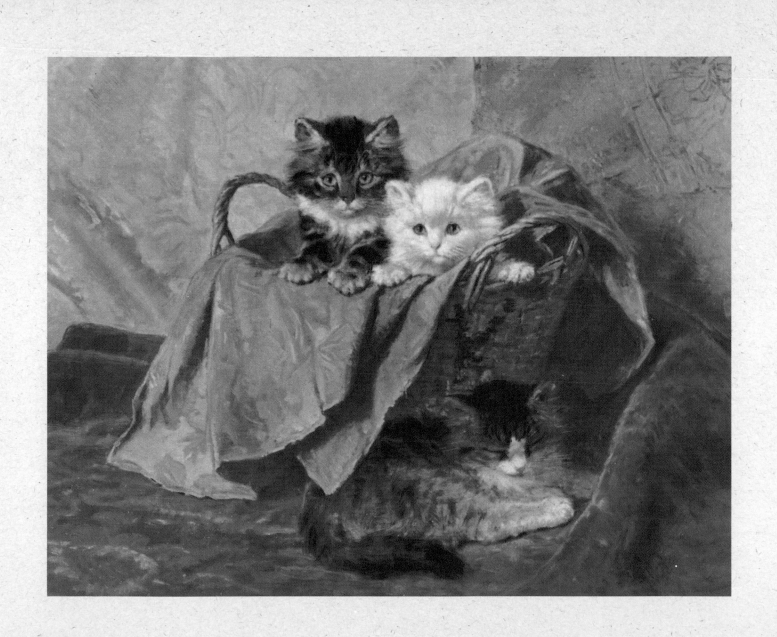

Sam raised his paw

for all the world

as if he were

about to protest,

and then,

apparently thinking

better of it,

he pretended

instead that the

action had been

only for the

purpose of

commencing his

nightly wash.

WALTER DE LA MARE
ENGLISH WRITER

THE CAT HAS NINE LIVES: THREE FOR PLAYING, THREE FOR STRAYING, THREE FOR STAYING.

English proverb

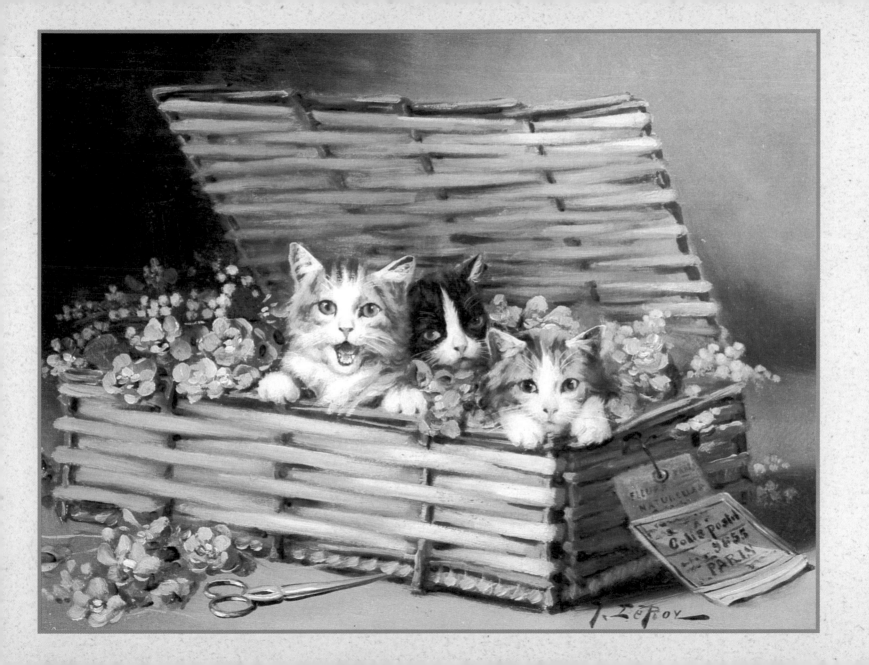

He sits...

thinking, as

he kneads

his paws,

what fun

to be a cat!

CHRISTOPHER MORLEY
AMERICAN WRITER

. . . IT WAS DIFFICULT TO FEEL VEXED BY A CREATURE THAT BURST INTO A CHORUS OF

PURRING AS SOON AS I SPOKE TO HIM.

Philip Brown
English writer

Continual wars and wives are what
Have tattered his ears and
battered his head.

TED HUGHES
ENGLISH POET

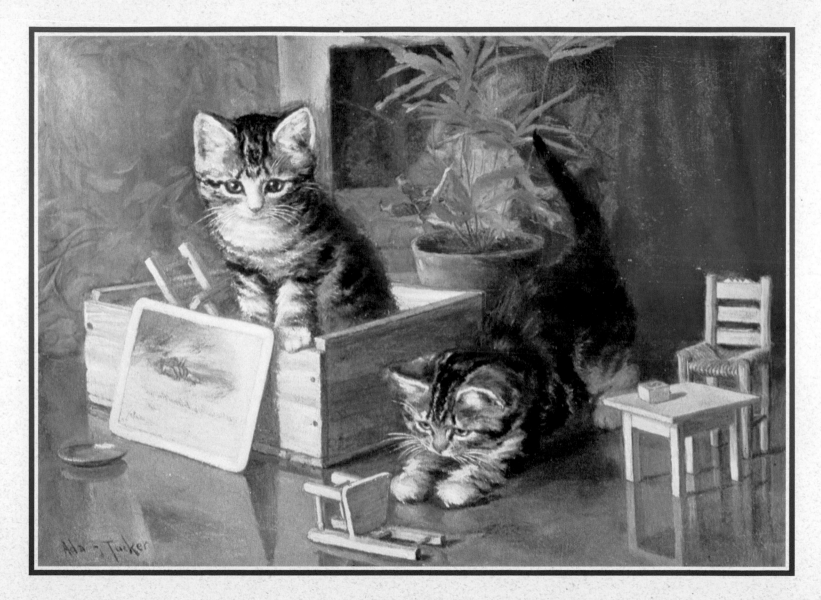

The fact is that, to cats, we humans are, for all our grotesque size, unbelievably slow and clumsy. We are totally incapable of managing a good leap or jump or pounce or swipe or, indeed, almost any other simple maneuver which, at the very least, would make us passable fun to play with.

CLEVELAND AMORY
AMERICAN WRITER

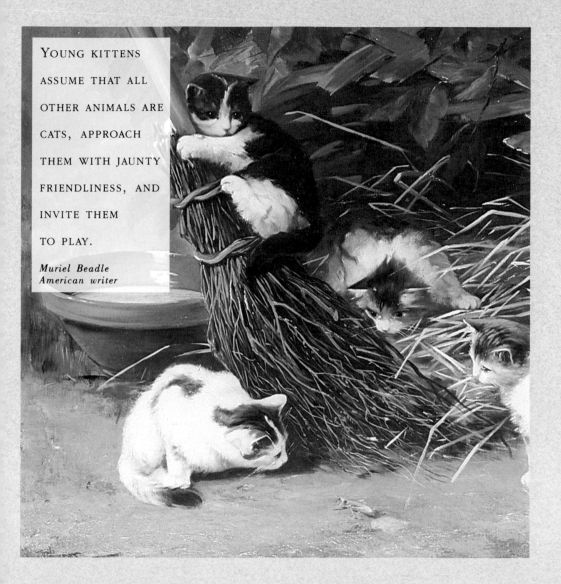

YOUNG KITTENS ASSUME THAT ALL OTHER ANIMALS ARE CATS, APPROACH THEM WITH JAUNTY FRIENDLINESS, AND INVITE THEM TO PLAY.

Muriel Beadle
American writer

If you want to be a psychological novelist and write about human beings, the best thing you can do is keep a pair of cats.

ALDOUS HUXLEY
ENGLISH WRITER

A KITTEN IS SO FLEXIBLE

THAT SHE IS ALMOST DOUBLE;

THE HIND PARTS ARE EQUIVALENT

TO ANOTHER KITTEN

WITH WHICH THE FOREPART

PLAYS. SHE DOES NOT

DISCOVER THAT HER TAIL

BELONGS TO HER

UNTIL YOU TREAD ON IT.

Henry David Thoreau
American writer

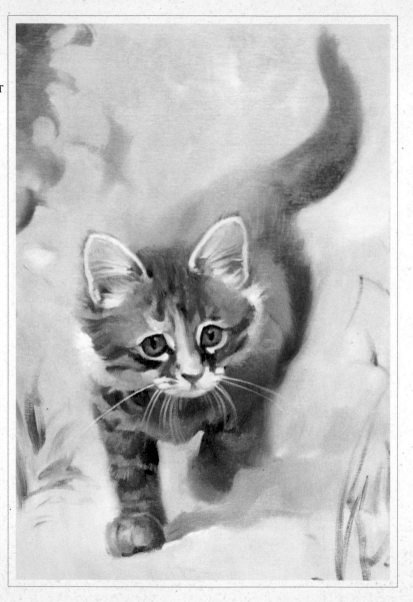

See the kitten on the wall,

Sporting with the leaves that fall,

Withered leaves, one, two and three,

Falling from the elder-tree;

Through the calm and frosty air

Of the morning bright and fair.

WILLIAM WORDSWORTH
ENGLISH POET

Wanton kittens make sober cats.

PROVERB

And the nearest kin of the moon,

The creeping cat, looked up.

Black Minnaloushe stared at the moon,

For, wander and wail as he would,

The pure cold light in the sky

Troubled his animal blood.

Minnaloushe runs in the grass

Lifting his delicate feet.

Do you dance, Minnaloushe, do you dance?

WILLIAM BUTLER YEATS
IRISH POET

they are curled into flowers
of fur, they are coiled
hot seashells of flesh
in my armpit, around my head
a dark sighing halo.

MARGE PIERCY
AMERICAN POET

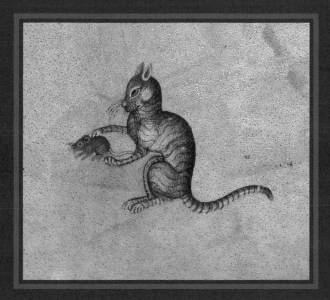

ILLUSTRATION ACKNOWLEDGMENTS